Have You Seen Mary?

Written by Jeff Kurrus
Photographs by Michael Forsberg

For LH and MK – JK
For EF and EF – MF

Have You Seen Mary?
Written by Jeff Kurrus
Photographs by Michael Forsberg
ISBN 978-0-9754964-1-1
Library of Congress Control Number: 2011918153

Book design by Reigert Graphics, Lincoln, Nebraska

First Edition, January 2012

Printed by The Covington Group, Kansas City, MO

Visit www.haveyouseenmary.com

Introduction

Dear Readers,

Before you read Jeff Kurrus's *Have You Seen Mary?*, one question must be asked: what parts of this fictional story are real?

Well, many parts are, starting with where Nebraska's visiting sandhill cranes come from. They spend their winters in northern Mexico and southern United States in places like Bosque del Apache National Wildlife Refuge in New Mexico. Then, during their spring migration, more than five hundred thousand cranes traveling north through what is known as the Central Flyway stop along the Platte River in Nebraska, making this the largest gathering of cranes in the world.

While in the Platte River valley, they eat corn left over from last fall's harvest for much needed energy. But like us, they need a balanced diet. They also forage for insects, snails, worms, mice, snakes, frogs and other plant material before eventually flying on to their nesting grounds in Canada, Alaska, and Siberia, sometimes covering five hundred miles a day.

Besides food, cranes stop at the Platte River in Nebraska because it is wide and shallow. Because they cannot roost, or sleep, in trees, cranes spend their nights in the cold, shallow river, away from predators like coyotes. Other predators include fox, bobcats, mountain lions, eagles, just to name a few. A crane's life, especially during migration, is never easy.

Cranes are also like us in many ways. Colts, or young cranes, in the same family fight with each other just like we do if we have brothers or sisters. Plus, crane families will also quarrel with other families. Cranes start their own families by dating, and will stay with one mate for a long time, often their entire lives. They live around twenty years, but there are scattered reports of wild cranes living into their thirties. As they age, they turn from a light brown color when they are young to gray as they grow up and even go bald.

Cranes also take baths and preen, or groom, their feathers. They wear a type of make-up, smearing reddish-colored mud on their gray feathers. One reason they do this is for camouflage. Another is to remove pests from their skin and feathers. Others believe they do it to pretty themselves for their mate. Plus, their voices even change as they grow up, which brings me to one more question: do cranes really talk?

Yes they do. Cranes look alike, but they have different sounding voices. They also have many different calls they use. One is the contact call. That is one of the calls that this story's characters, John and Mary, would use in real life to find each other. Cranes also use body language and even the red patch, which is actually skin, to communicate. Think how you tell others how you are feeling just by the way you hold your body or use your eyebrows. Cranes are doing the same thing.

By reading this story, I hope you'll see that sandhill cranes are, in many ways, just like us. But what I really hope is that this book makes you want to learn even more about these fascinating animals.

— *Keanna Leonard*
Director of Iain Nicolson Audubon Center at Rowe Sanctuary, Nebraska

When John and Mary Crane finally cupped their wings toward the Platte River in Nebraska after flying more than six hundred miles from New Mexico, the same excitement that filled them each year was back again.

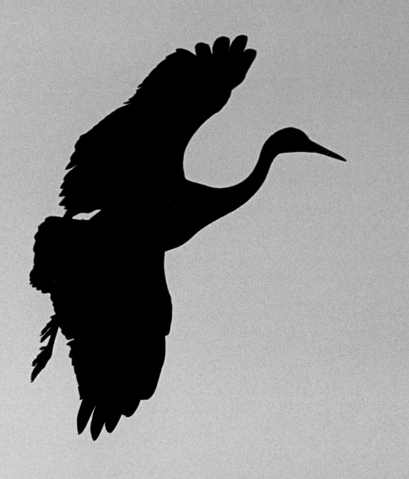

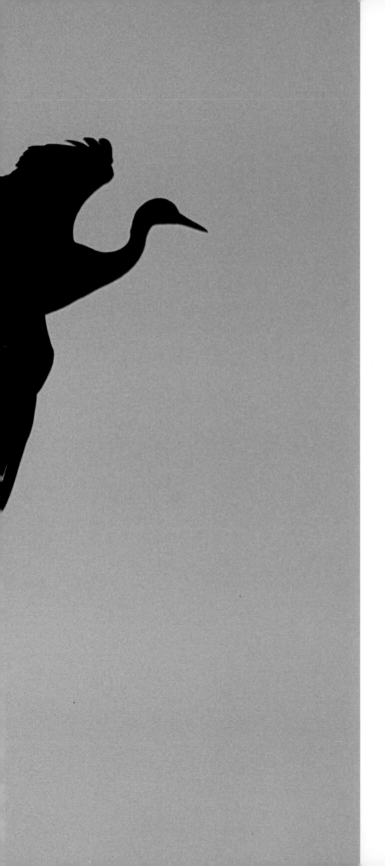

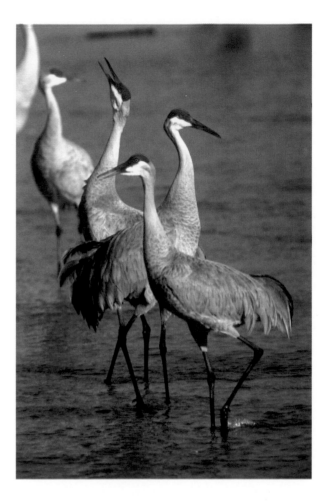

For them, this river brought
back so many memories –
from watching their chicks
grow up and start their own
families ...

... to admiring the wide open sunsets
that only Nebraska could offer.

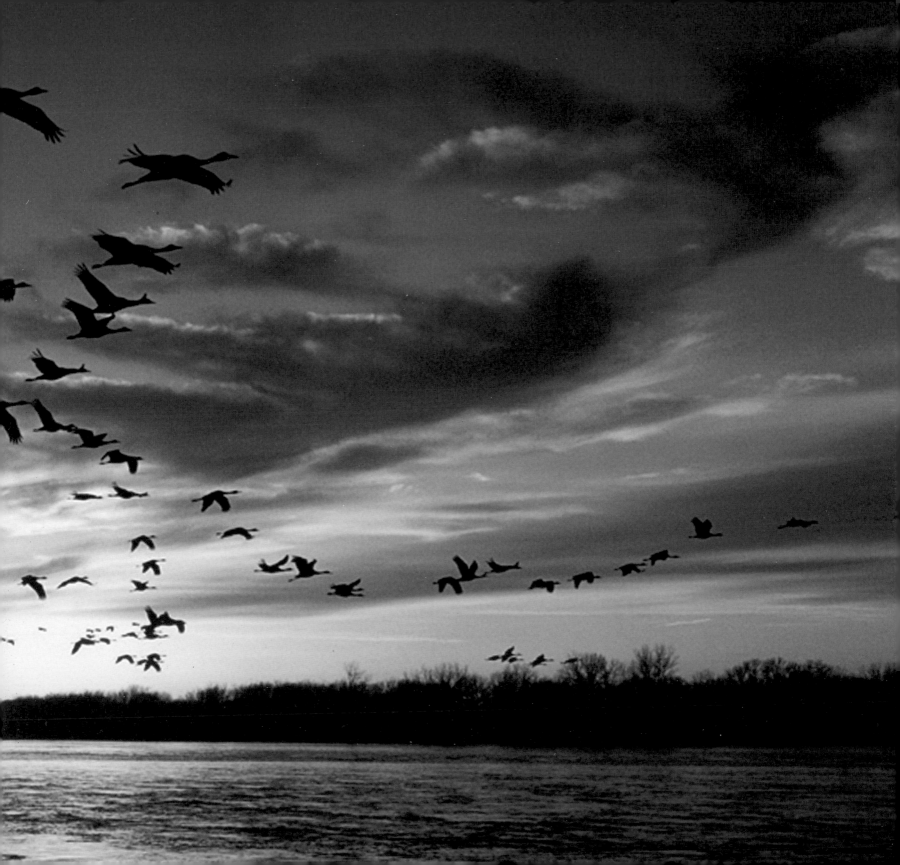

However, this year was different than most. With no young of their own, all of their time would be dedicated to building strength for the last leg of their flight to their breeding grounds in Alaska.

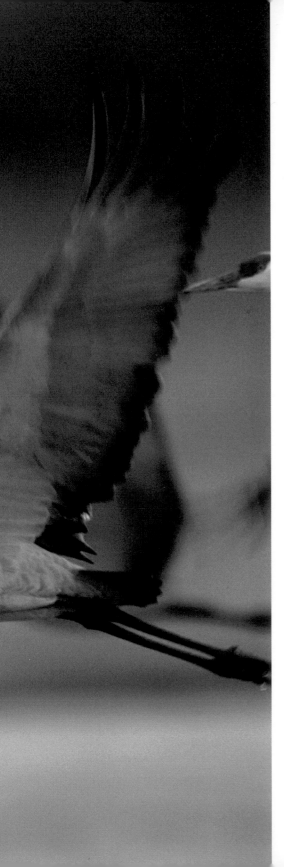

Corn, snails, earthworms, and water – oh yes, sweet Platte River water – would add the energy needed for their journey home.

They drank when they landed, each swallow filling every inch of their tired bodies.

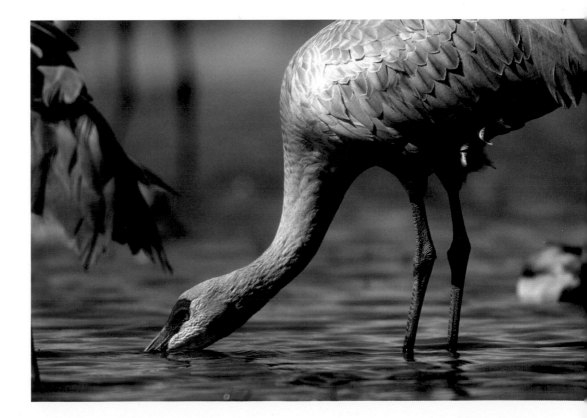

Until fear
filled their
worlds.

A coyote
stalked
near …

… and the sky blackened with dark, gray bodies.

In the blurry confusion, John lost Mary.

When John
landed back
onto one of
the many
sandbars
along the river,
he did not
search for her.

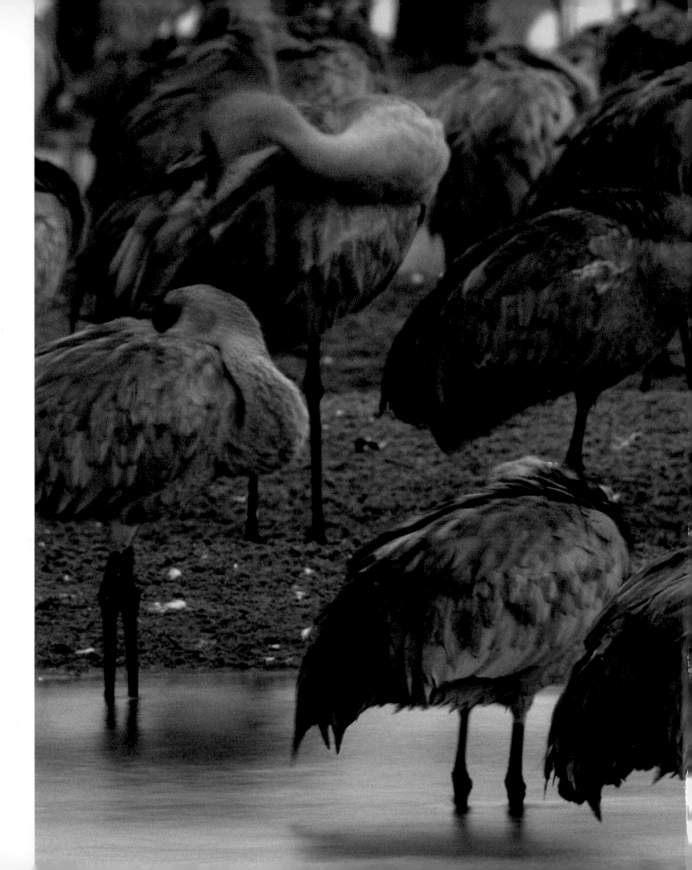

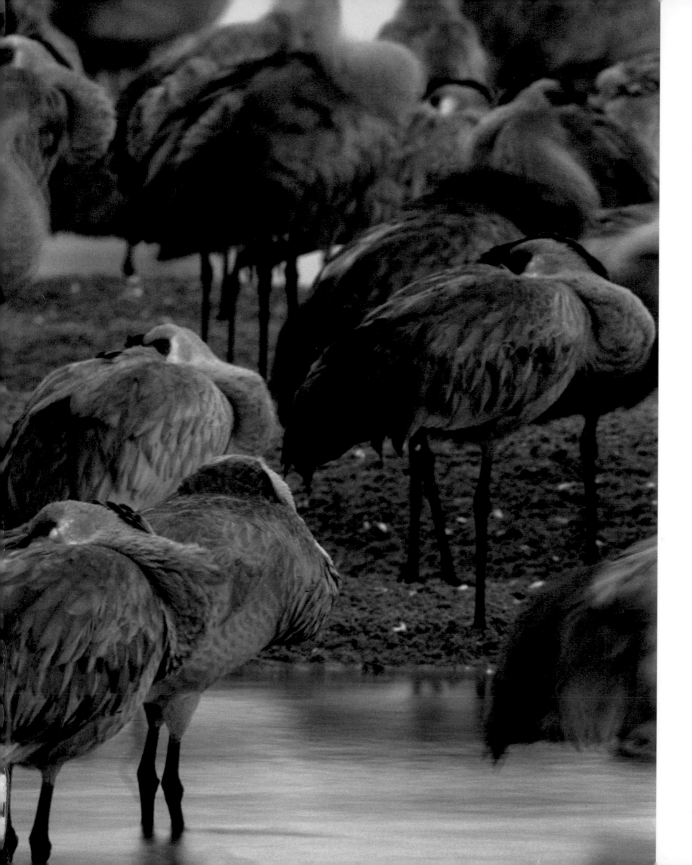

"We will meet again tomorrow," he thought, tucking his head beneath his wing to get some much needed rest.

The following morning, John walked along the cold, shallow river. Everywhere he looked he saw cranes, and crane tracks, but no Mary.

"Are crane feet like snowflakes?" he wondered. He knew her feathers and the sound of her voice, but had no idea what her feet looked like. Why hadn't he paid more attention?

As he searched,
he watched
cranes fight.

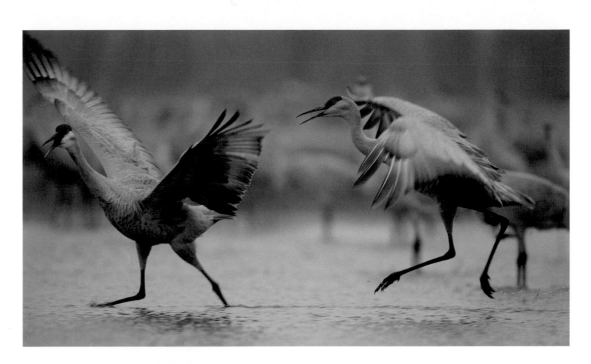

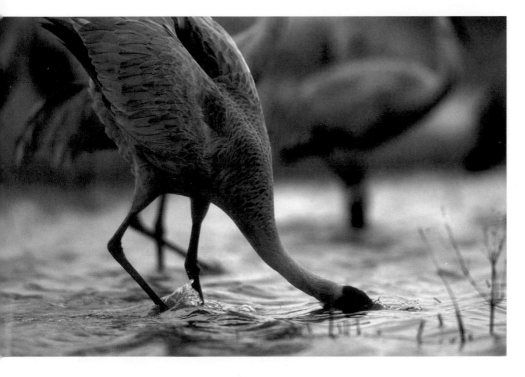

And he watched
them bathe.

But not once did he see Mary.

Finally, John approached another crane.

"Excuse me," he said. "Have you seen Mary? She stands about four feet tall, and has the most beautiful gray feathers on all the Platte."

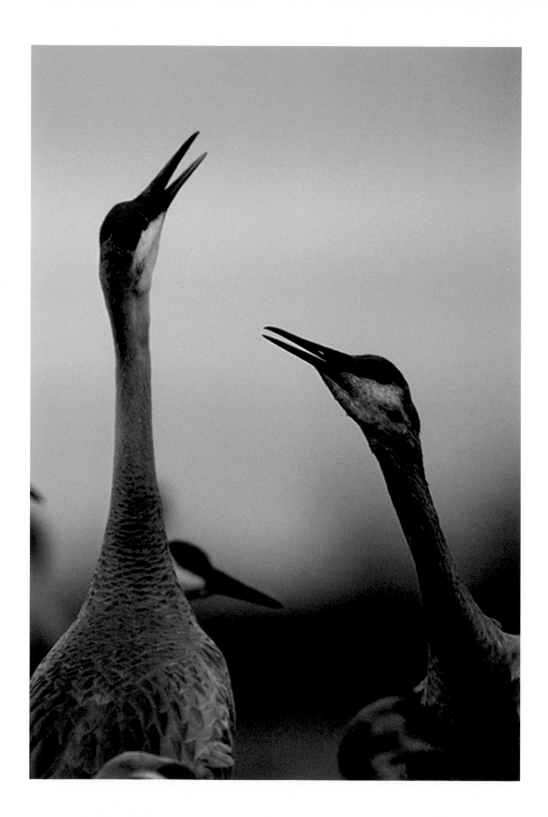

"You're going to have to narrow that down a little," the crane said. "We all look like that."

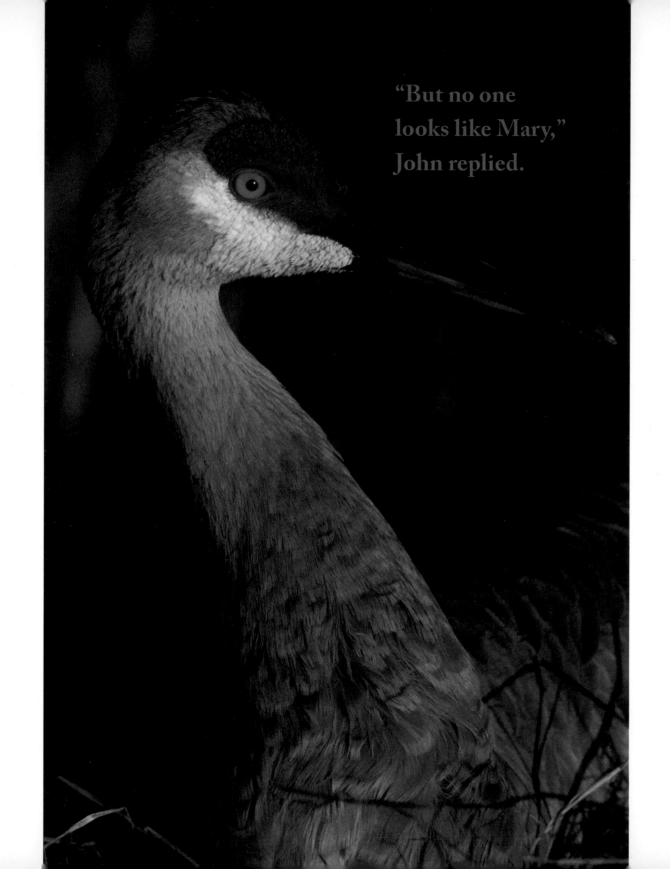

"But no one
looks like Mary,"
John replied.

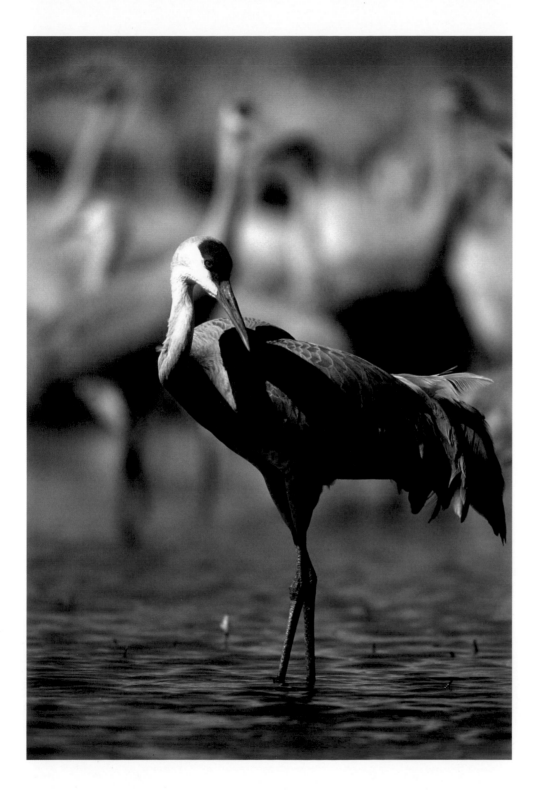

"Just like no one looks like her," the other crane responded with a smile, pointing to his preening soul mate.

John thanked him and continued his lonely walk down the river.

As he explored, he remembered their early summer mornings at
Denali National Park in Alaska …

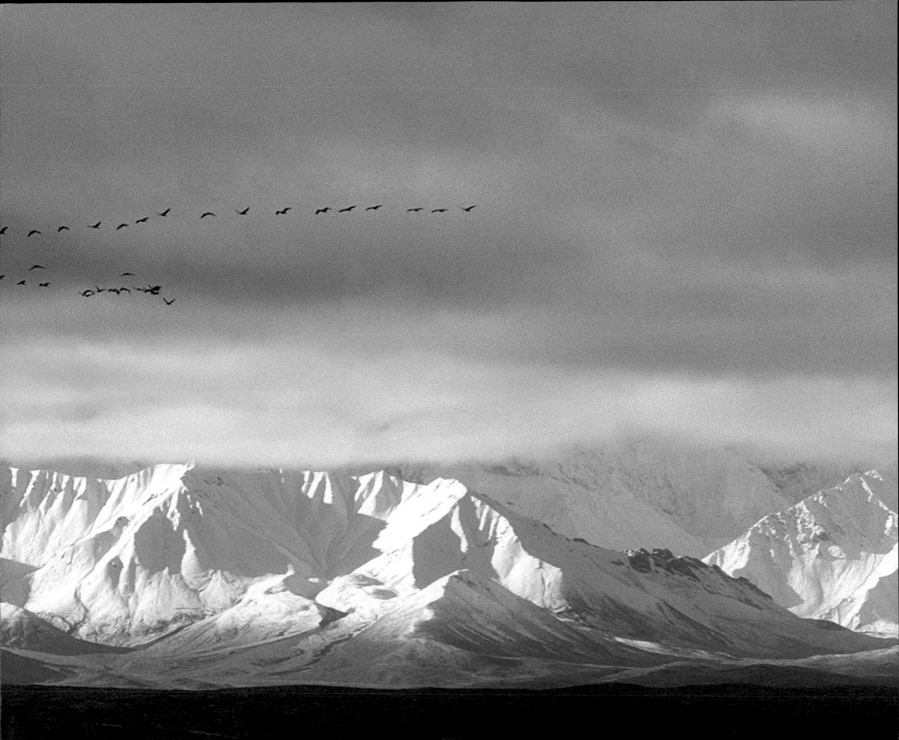

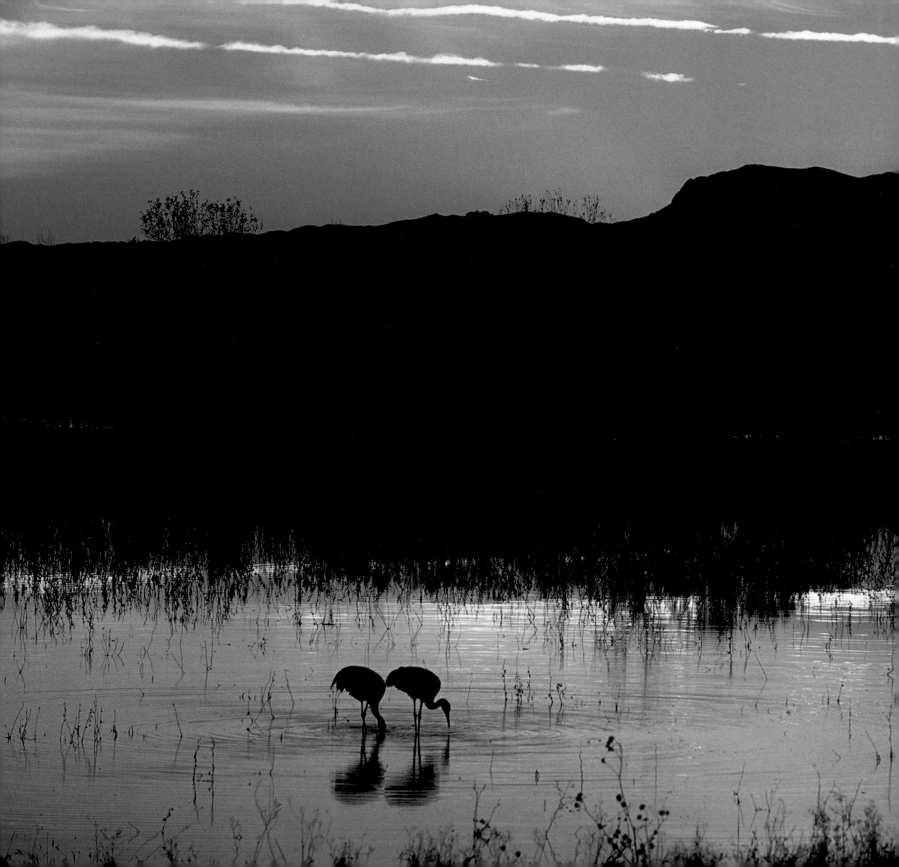

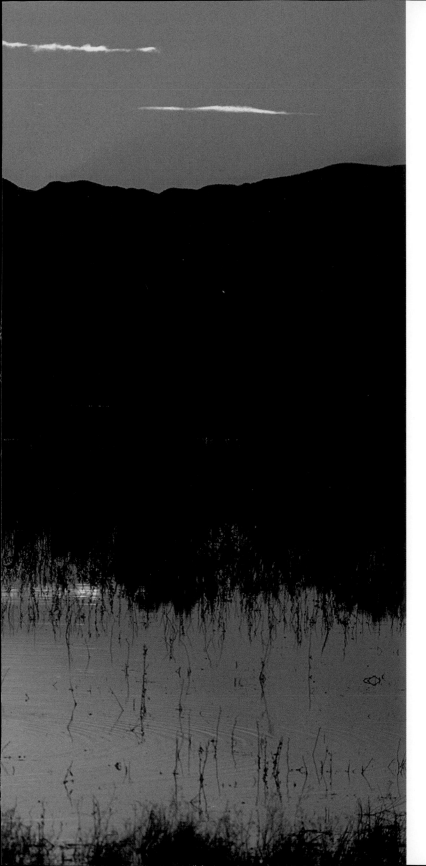

... and their late winter afternoons at Bosque del Apache National Wildlife Refuge in New Mexico.

John was brought back to the present as flock after flock flew from the river. His heart sank low in his chest, for not once did he hear her voice or see the glow from her feathers.

The cranes would now be separated along the Platte, from the towns of Grand Island to Lexington, in more than eighty miles of fields, creeks, and meadows. It could take him all day to find her. He lifted into the air and continued his search.

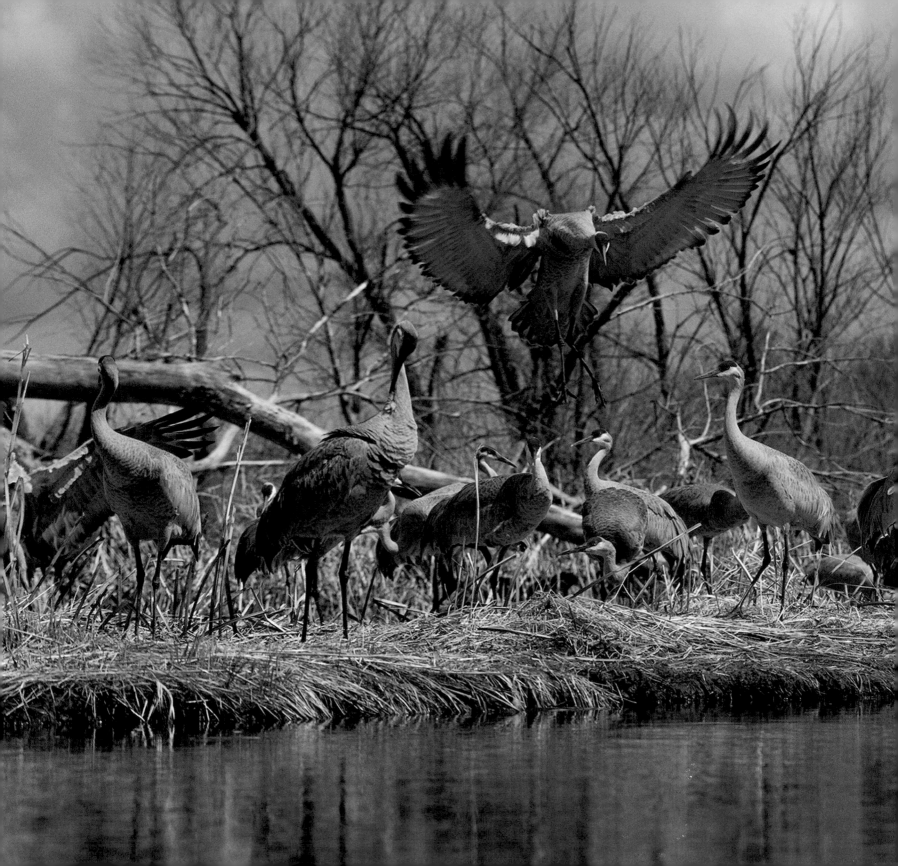

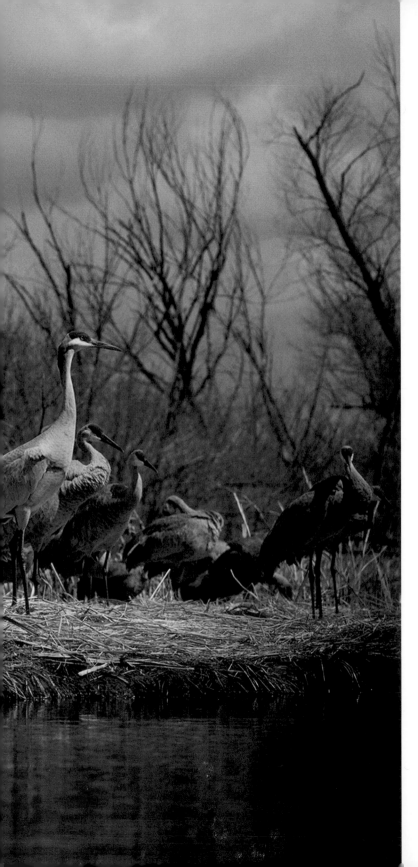

His first stop was near the town of Wood River. Long ago, Mary had convinced him that the fields there had the tastiest insects on the Plains. He landed near a flock of cranes, more than one hundred birds.

"Excuse me," he asked the group. "Do you know Mary from the Yukon Delta?"

"No," said one crane.
"Not me," said another.
"Uh-uh," said a third,
and the rest just shook their heads.

So then he asked one deer.

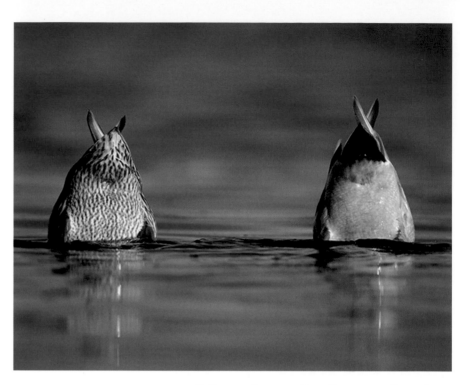

Next he asked two ducks.

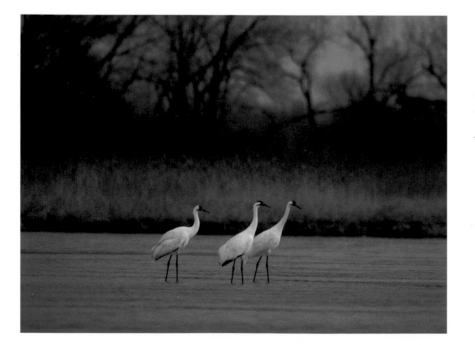

Finally he asked three whoopers.

But they all said no.

Near sunset, John had a new idea. He would go back to the Platte, where they had first landed the night before, and watch every flight return to roost.

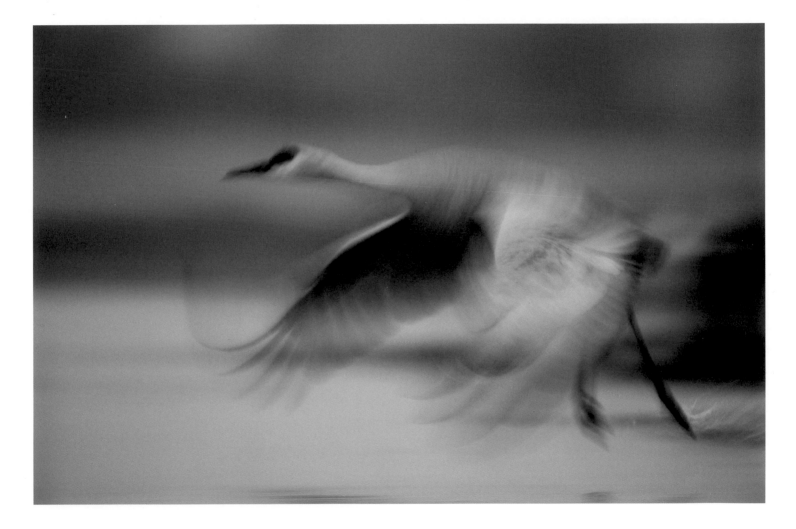

The idea gave him hope, and he quickly flew to the river.

But that hope quickly disappeared as cranes came to roost. When he thought there couldn't possibly be space on the Platte for another bird, a thousand more would land.

"Why didn't we talk about what we would do if we were ever separated?" he asked himself. "Why didn't we have a plan?"

He repeated questions to himself as light disappeared from the day. It was going to be a long night. Because he could not sleep he guarded a nearby flock, eyes wide and alert.

As he watched the nearby banks for predators, he asked himself more questions.

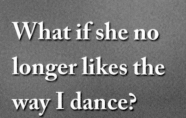

What if she no longer likes the way I dance?

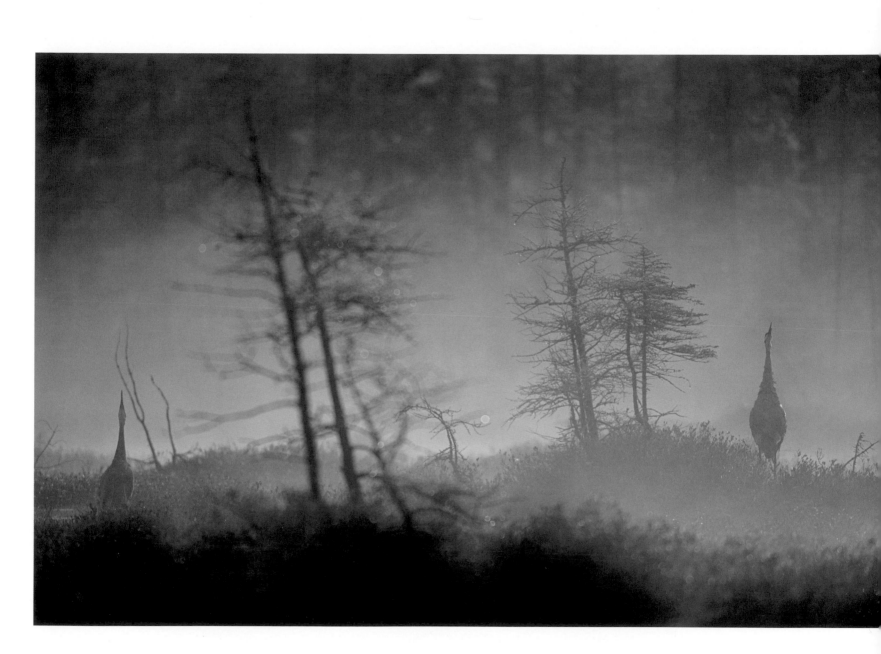

Or the way I unison call?

What if she has found someone new?

He closed his eyes and prayed, remembering their
past flights together.

His search continued for nearly a month as he asked countless animals if they knew her.

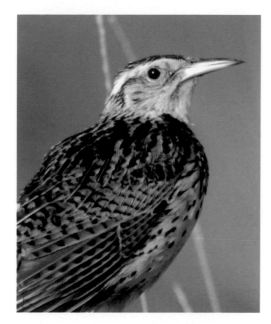

This is how she flies,
he told the meadowlark.

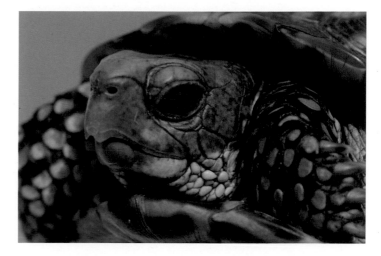

This is how she paints herself with mud on the nest, he told the ornate turtle.

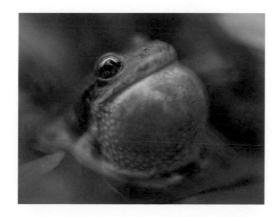

This is how she sounds when she's happy, he told the chorus frog.

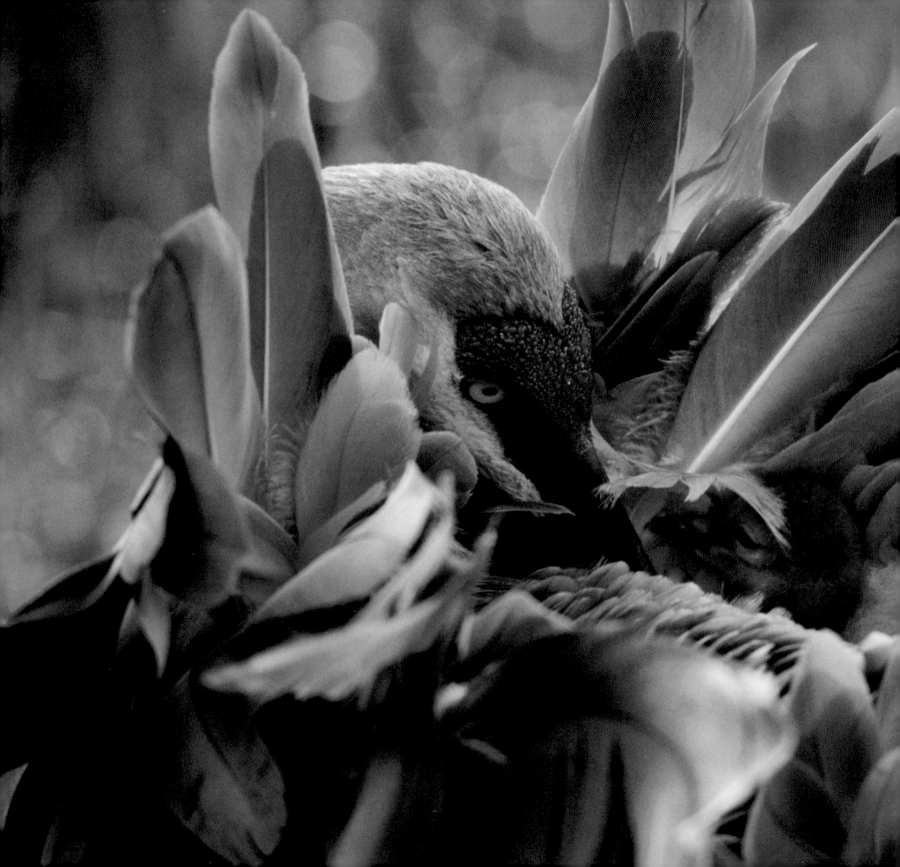

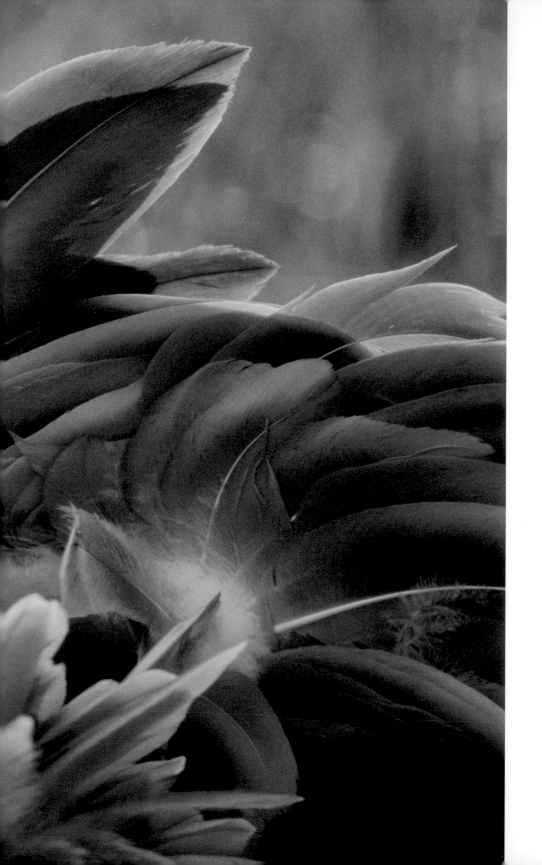

And this is how she holds our chicks, he told everyone.

But not one animal
had seen Mary.

By the afternoon of John's thirtieth day, he was weary. He had drunk little and eaten less. He was ten years old, not very old for a sandhill crane, yet he felt twice that. Lost, and more tired than he had ever been, he leaned over for a drink.

There, in a blade of grass by the river's edge, was a lone feather shining brighter than any he had ever seen. "Mary," he spoke. But when he turned to look for her, she wasn't there.

"There is one more place to look," he said, thinking of the spot he had avoided since their arrival – the powerlines.

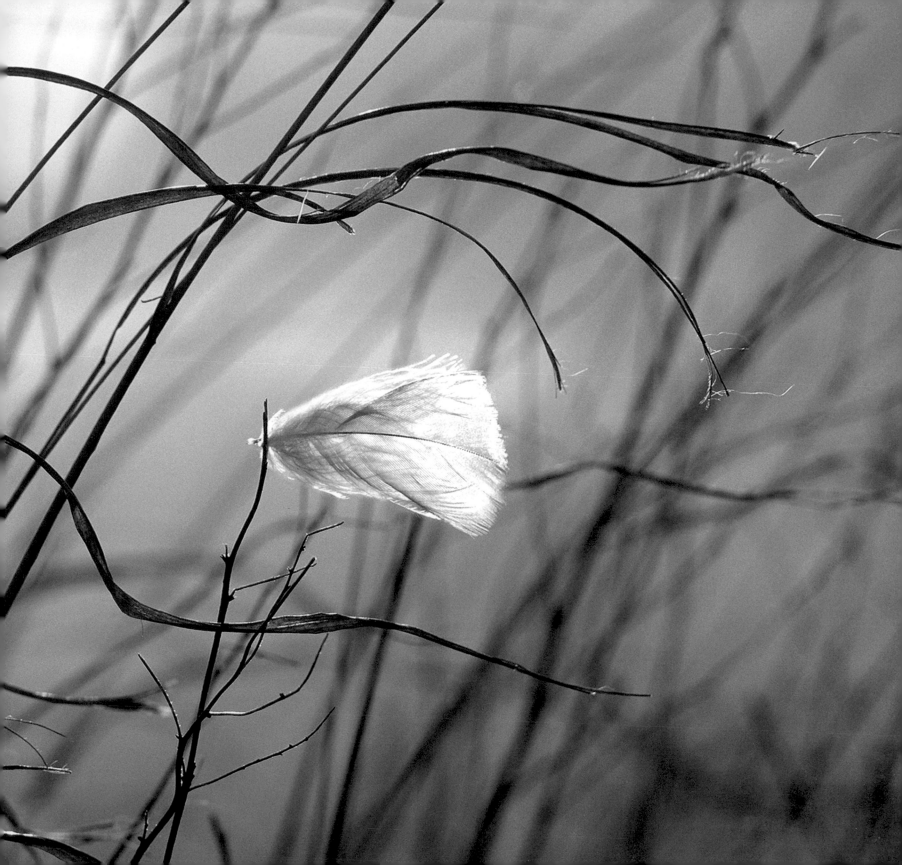

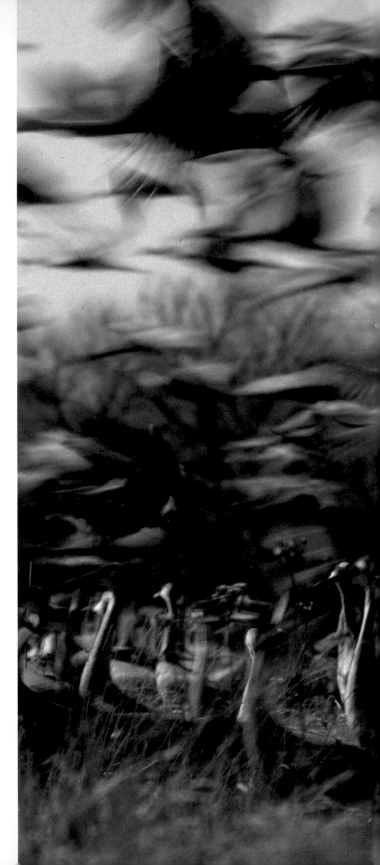

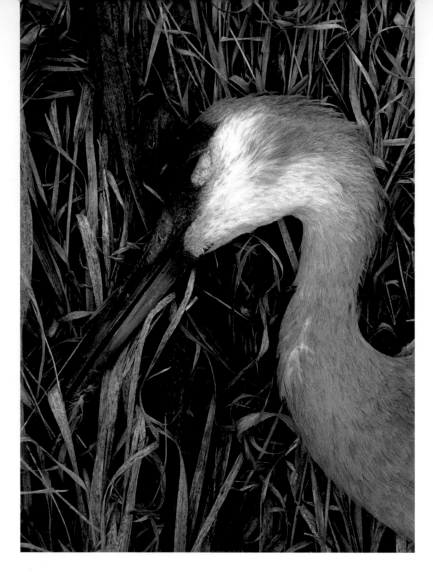

Each year hundreds of birds were killed by
flying into powerlines crossing the Platte.
While large yellow markers were recently added
so cranes could see them better, that still
didn't keep some birds from flying into them.

John walked hesitantly in their direction.

And despite all the noise around him, the loudest sound was his nervous heart.

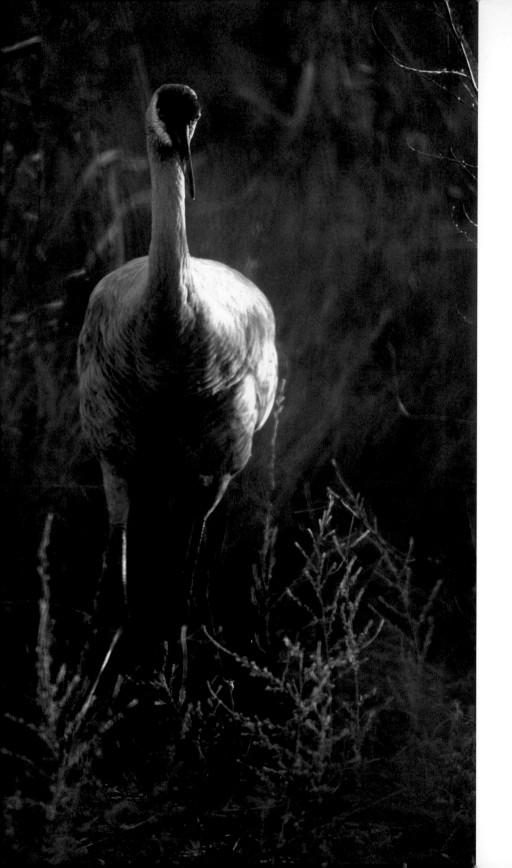

Yet when he arrived at the lines, she was not there. Momentarily relieved, he looked up and saw cranes everywhere. "I may never find her," he thought.

"It looks like someone hasn't been eating," floated a sweet and distinctive voice from behind John, and he knew it was Mary even before he turned.

To the untrained eye, there was no difference. Gray, with a red patch above her eyes, she looked the same as any other crane.

Except she glowed different than all the others.

"I've been looking for you," he said.
"And I for you," Mary replied. "I've been leaving feathers for you."
He leapt as high as he could, staring into her eyes as he did.
"I love it when you do that," she said. "The way you dance, the way you
call – I love everything about you."

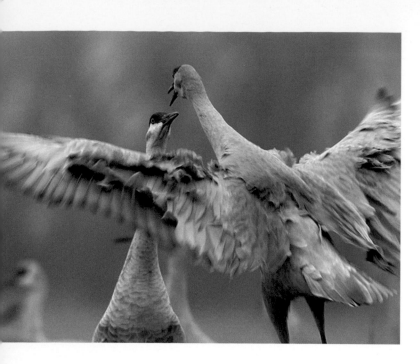

There was so much to say, so much
to share, but all they could do was
look at each other. Finally, Mary
spoke. "It looks like we'll have a
beautiful sunset. And in the
morning we have to fatten you up.
We have a long trip north soon."

"I don't want to think about
flying yet," he said. "I just want to
be here, with you."
"Me too," she replied.

Together, for what seemed like the first time ever, they watched a Nebraska sunset.

There was no place in the world they would rather be.

Afterword

I have always been fascinated with how books are constructed, but very seldom have I been privileged to see this process. Because writing is such a solitary endeavor, even writers are often unsure of how others piece together their works. Therefore, because of my own interest in this subject, I'm happy to share with others the evolution of this little book.

In March of 2011, I asked myself the following question after a recent crane viewing trip – what happens if a sandhill crane loses his/her mate? Then, after more thought, I called friend and wildlife photographer Michael Forsberg and asked him a different question: "Would you consider supplying photos for a children's book?" His "yes" was all I needed.

For the next two months, while referring to multiple birding web sites and crane books, including Mike's *On Ancient Wings – The Sandhill Cranes of North America,* I began telling the story of two cranes, John and Mary. The tale was woven from constant note scribbling, repeated audio recordings, and frequent late-night laptop sessions. Once my rough draft was written, I slowly began to pick through Mike's photos for ones that matched the story I wanted to tell. Then I re-read, and subsequently, re-wrote the text. So in the age-old chicken/egg debate, mine was simple: first came the words, next came the photos, and finally came the story.

Then, with much trepidation, I sent my draft to Mike. His three-word reply was both a relief and a burden: "I'm all in." Now I had to keep going. I re-worked the text for the next four months, employing friend and colleague Tim Reigert for design and layout and Rowe Sanctuary's Keanna Leonard to write the Introduction. Then came the review process, starting with my sister Amy and continuing with educators in Nebraska, including 4th grade teacher Kate Crowe from Dodge Elementary School in Grand Island, 4th grade teacher Jane Gundvaldson from Squire John Thomas Elementary in Gretna, 3rd grade teacher Connie Healey from Sheridan Elementary School in Lincoln, and Chris Vos's entire 4th grade class at Gretna Elementary School. Their input helped me sleep well at night. As did the additional support from the Museum of Nebraska Art's Merilyn Anderson, Nebraska Visitor and Nature Center's Brad Mellema, Joslyn Art Museum's Jane Precella, Pioneers Park Nature Center's Nancy Furman, the Bookworm's Ellen Scott, Fontenelle Nature Association's Julie Huffman and Connie Stevenson, and the good folks at the Nebraska Game and Parks Commission.

By August, I had a printer, a distributor, and was confident enough to allow my most ardent critics a look at *Have You Seen Mary?* These included Mom, Dad, Barb, Chris, Doug, Gena, Greg, Harry, Jarel, Jill, Jo, Jon, Kathy, Kim, Kristen, Lindsay, Margie, Matt, Patty, Peg, Rex, Terry, and my dear wife Laura. It was from this entire group – from editors, to kids, to longtime friends and colleagues – that I learned a valuable lesson: it takes a village to write a children's book. Still, I would be lying if I told you I have a fingernail left just two weeks before this book goes to press. For when it finally appears on the shelf, it will be important that readers not only find the photography beautiful, but also a story that entertains and educates.

— *Jeff Kurrus*
September 27, 2011